CAT
ALPHA-
BET

CAT ALPHABET

THE METROPOLITAN MUSEUM OF ART · NEW YORK

A BULFINCH PRESS BOOK / LITTLE, BROWN AND COMPANY

BOSTON · NEW YORK · TORONTO · LONDON

First edition
Second printing June 1997

Library of Congress catalog card number 93-81026
isbn 0-87099-692-4 (mma)
isbn 0-8212-2129-9 (Bulfinch)

Published by The Metropolitan Museum of Art, New York, and
Bulfinch Press
Bulfinch is an imprint and trademark of Little, Brown and Company (Inc.)
Published simultaneously in Canada by Little, Brown & Company (Canada)
Limited

Produced by the Department of Special Publications,
The Metropolitan Museum of Art
Photography by The Metropolitan Museum of Art Photograph Studio
Designed by Tina Fjotland

Printed in Singapore

Sleeping everywhere, especially in sunlit spots. Disdainful of affection, playmate to your furniture, respecter of no surface. As you read, your book is gently nudged, and a pair of paws appears on its pages. You will read no more until you acknowledge your pet with a few rubs behind the ears. Then the cat's gone. No reassuring and obedient head in your lap for an evening's company.

A noise in the night. Startled from sleep, you sit up and see your cat chasing its favorite toy across your bedroom, batting it from side to side and then pouncing. No dog would dare.

Elegant, aloof, omnipresent—as you'll see turning the pages of this book. Other animals, domestic or wild, are appreciated for their constant and predictable natures—the gentle lamb, the faithful dog, the contented cow. But cats are everything and everywhere, from A to Z.

Maron L. Waxman

Aristocat

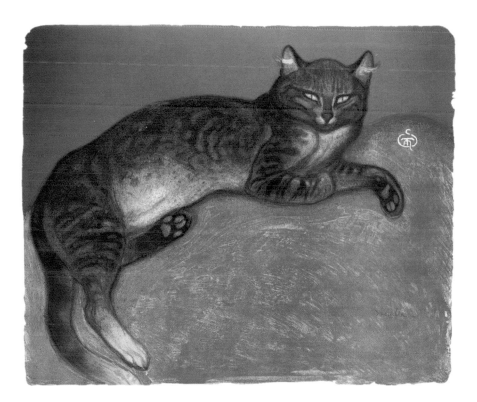

CAT BURGLAR

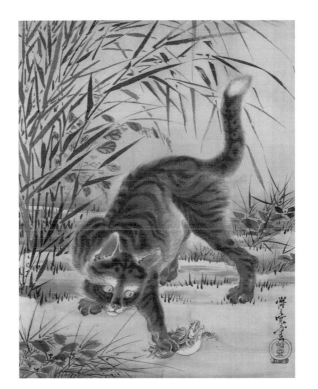

COPY

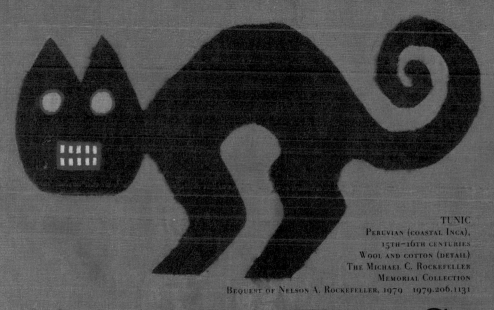

TUNIC
PERUVIAN (COASTAL INCA),
15TH–16TH CENTURIES
WOOL AND COTTON (DETAIL)
THE MICHAEL C. ROCKEFELLER
MEMORIAL COLLECTION
BEQUEST OF NELSON A. ROCKEFELLER, 1979 1979.206.1131

C A T S

Demo-cat

THE FAVOURATE CAT AND DE LA-TOUR, PAINTER
John Kay, Scottish, 1742–1826
Etching from *Portraits of Eminent Scotch Characters* (detail), 1813
Harris Brisbane Dick Fund, 1917 17.3.756-617

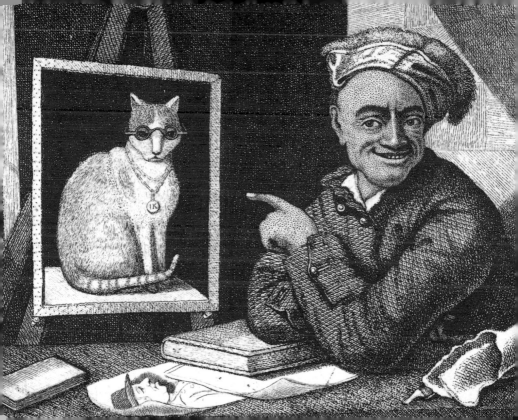

ETERNAL CAT

STATUE OF A SACRED CAT
Egyptian, Ptolemaic period, 305 b.c.–30 b.c.
Bronze
Harris Brisbane Dick Fund, 1956 56.16.1

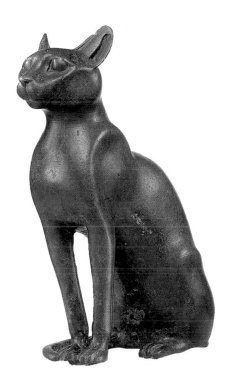

FAT CAT

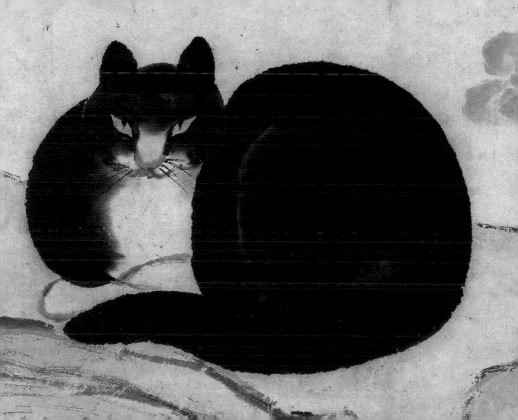

GLAMOUR PUSS

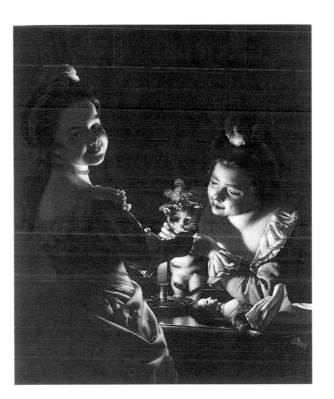

Hellcat

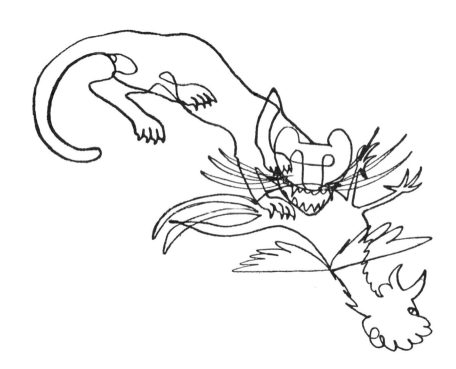

INSCRUTABLE CAT

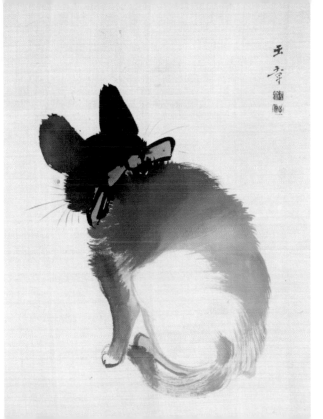

JUNGLE CAT

THE REPAST OF THE LION
HENRI ROUSSEAU, FRENCH, 1844–1910
OIL ON CANVAS (DETAIL), CA. 1907
BEQUEST OF SAM A. LEWISOHN, 1951 51.112.5

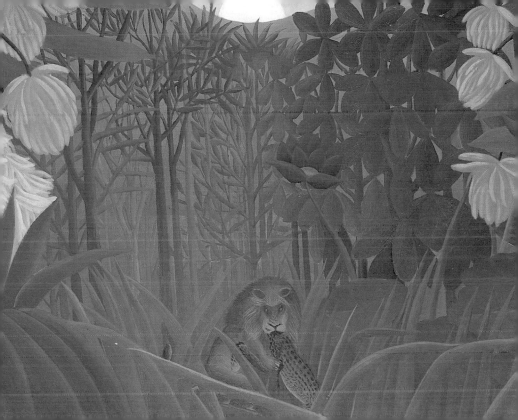

KITTY CAT

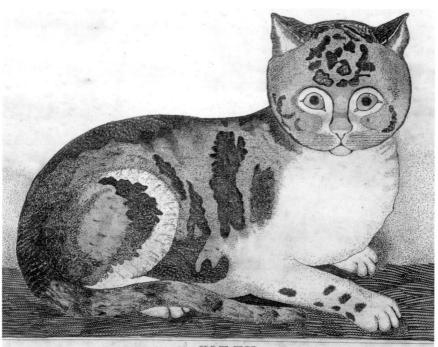

KITTY

LAP CAT

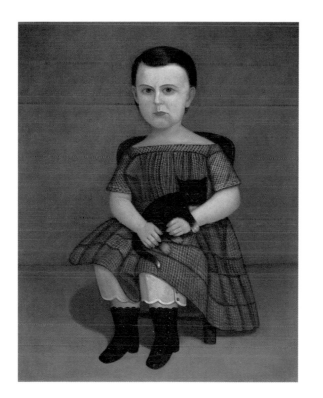

METROPOLITAN CAT

DAILY NEWS
DONA NELSON, AMERICAN, B. 1952
OIL ON CANVAS, 1983
PURCHASE, EMMA P. ZIPRIK MEMORIAL FUND GIFT, IN MEMORY OF
FRED AND EMMA P. ZIPRIK, 1984 1984.266

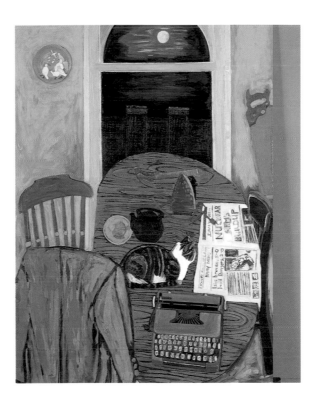

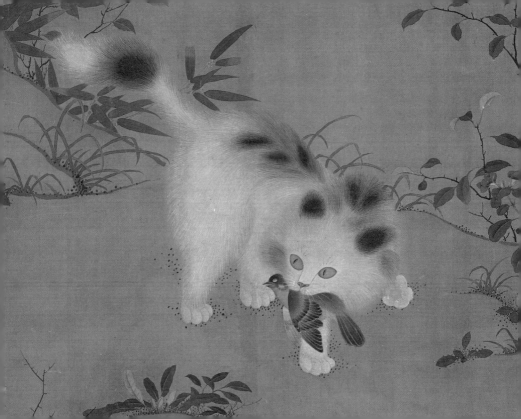

CAT **N**IP . . .

SPRING PLAY IN A T'ANG GARDEN
CHINESE, 18TH CENTURY
HANDSCROLL (DETAIL), COLOR ON SILK
FLETCHER FUND, 1947 47.18.9

CAT NAP

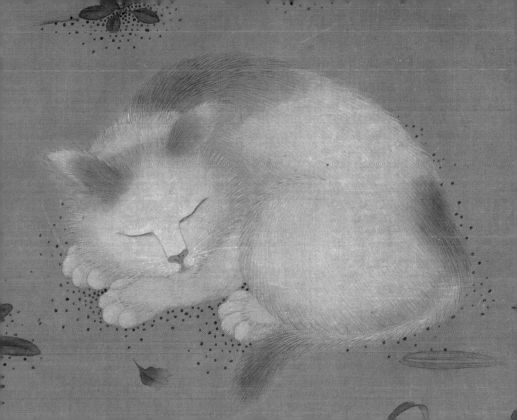

OGLING CATS

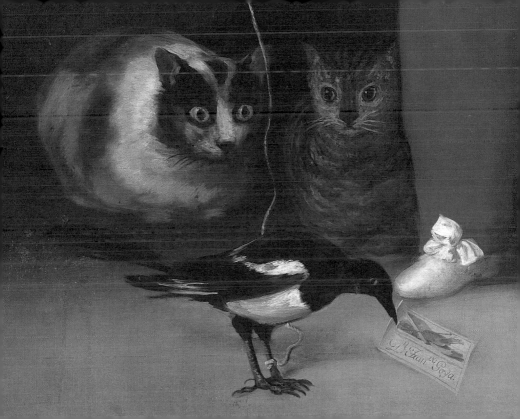

PREYING CAT

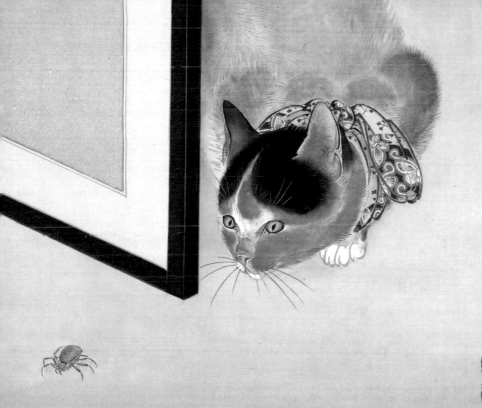

QUASI CAT

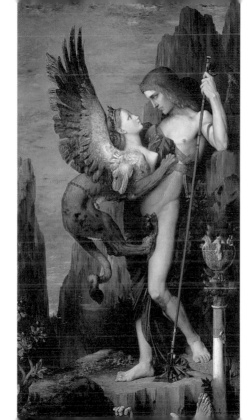

REGAL CATS

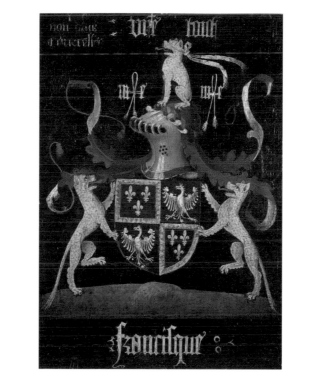

SOPHISTICAT

KIESLER AND WIFE
WILL BARNET, AMERICAN, B. 1911
OIL ON CANVAS, 1963–65
PURCHASE, ROY R. AND MARIE S. NEUBERGER FOUNDATION, INC. GIFT
AND GEORGE A. HEARN FUND, 1966 66.66

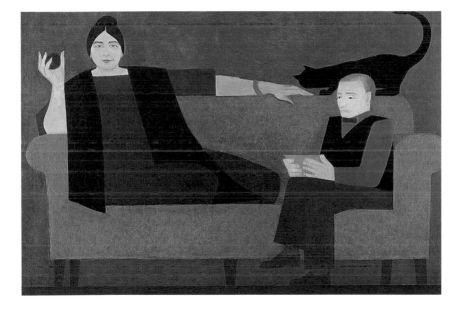

TEA CATTY

COMPAGNIE FRANÇAISE DES CHOCOLATS ET DES THÉS
Théophile-Alexandre Steinlen, French, 1859–1923
Color lithograph, 1899
Gift of Bessie Potter Vonnoh, 1941 41.12.19

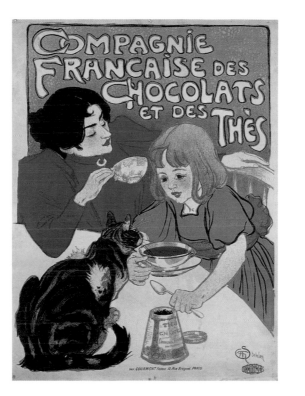

UNDERCOVER CAT

JOSEPH INTERPRETING THE DREAMS OF HIS FELLOW PRISONERS
MASTER OF THE STORY OF JOSEPH, NETHERLANDISH, ACTIVE CA. 1500
TEMPERA AND OIL ON WOOD
HARRIS BRISBANE DICK FUND, 1953 53.168

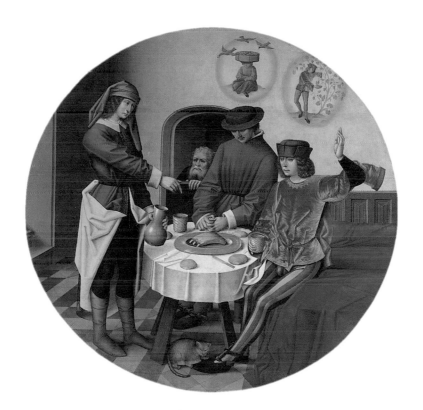

VIVE LE CHAT!

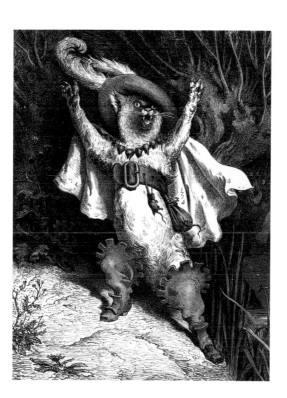

CAT WALK

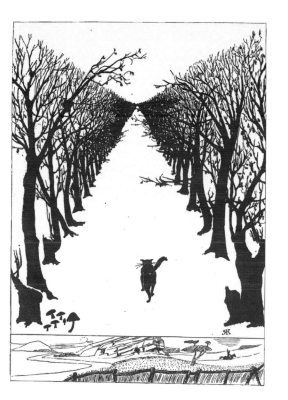

Xmas cat

HARPER'S CHRISTMAS

YANKEE CAT

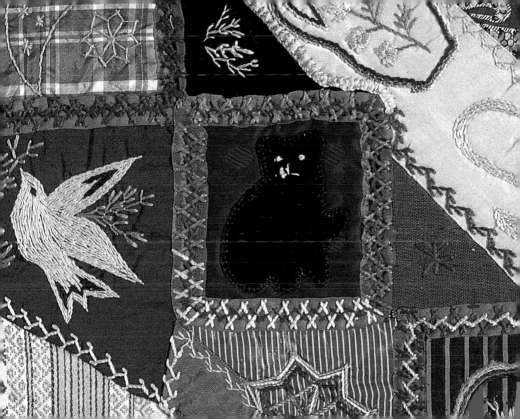

ZEN CAT

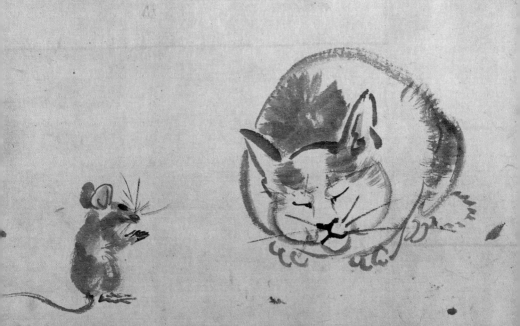